When I was down beside the sea

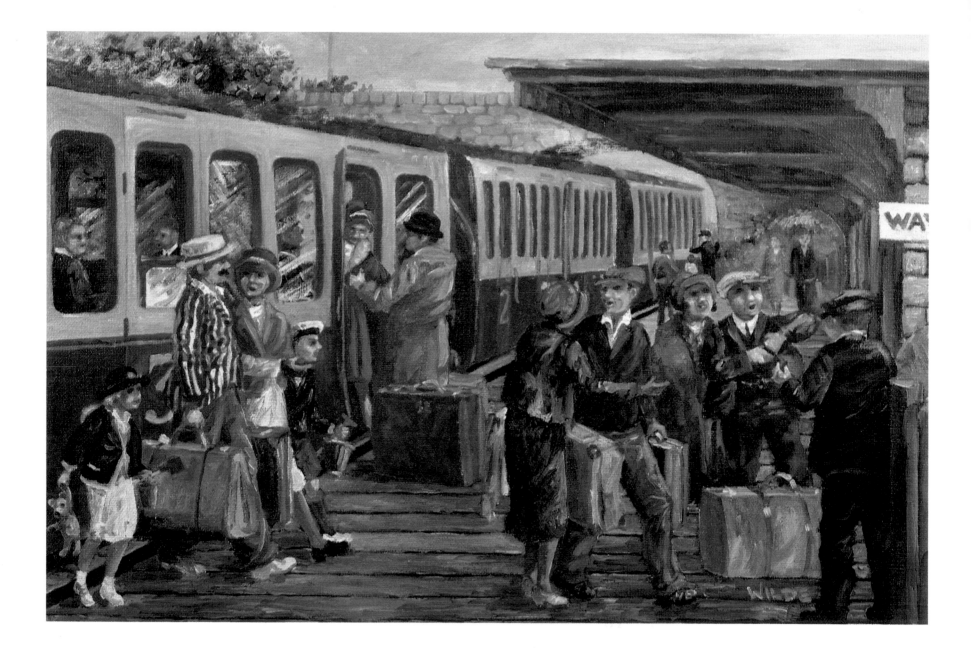

When I was down beside the sea
Fred Wilde

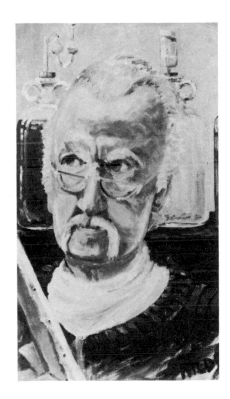

Collins
8 Grafton Street, London W1
1984

William Collins Sons & Co Ltd
London · Glasgow · Sydney · Auckland
Toronto · Johannesburg

First published 1984

© Fred Wilde

Produced for Collins by the Cupid Press
2 Quay Street, Woodbridge, Suffolk

Designed by John and Griselda Lewis

Made and printed in Great Britain by
W. S. Cowell Ltd, Ipswich

ISBN 0 00 21780 5

Contents

When I was down beside the sea

When I was down beside the sea,
A wooden spade they gave to me
 To dig the sandy shore.
My holes were empty like a cup,
In every hole the sea came up,
 Till it could come no more.

ROBERT LOUIS STEVENSON
A Child's Garden of Verses

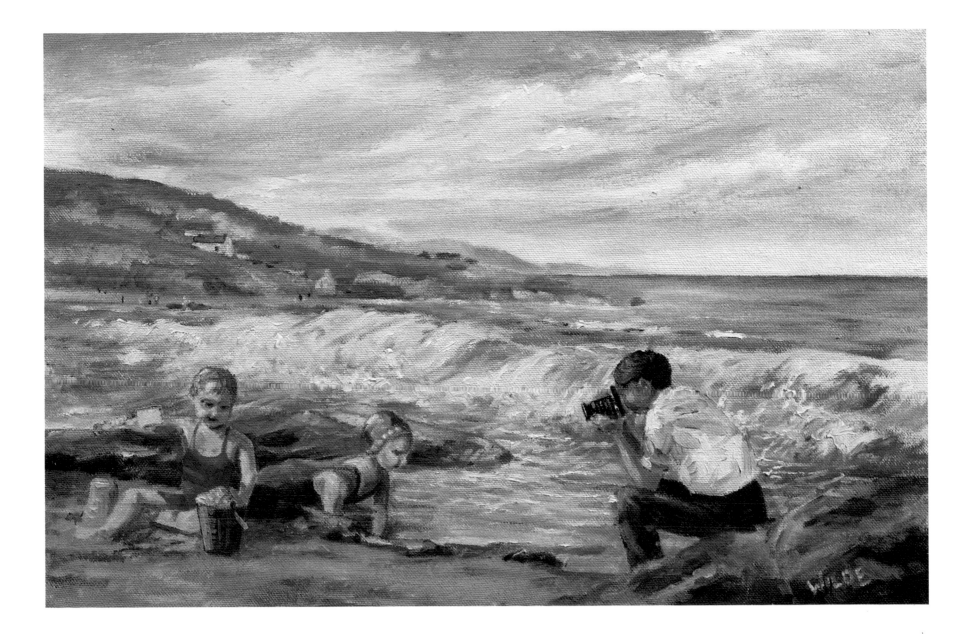

Waitin' fer t'Sharra

Its posh name was 'char-a-banc'; now it has become a 'motor-coach'. But for us in those days it was always a 'sharra'. It took us on day trips or holidays quite a lot more cheaply than the railway, and you'd see groups of people lining up for it at regular stopping places.

The 'sharra' had bench seats, all facing forward, each row with its own door, to seat four people. All the seats were open to the air. If it rained the only protection was a sort of large 'pram-roof' which folded up and collapsed upon itself behind the back row of seats when not in use.

These new-fangled waggonettes funnelled hordes of day-excursionists and holiday-makers to their wakes-week havens as more and more people enjoyed more leisure.

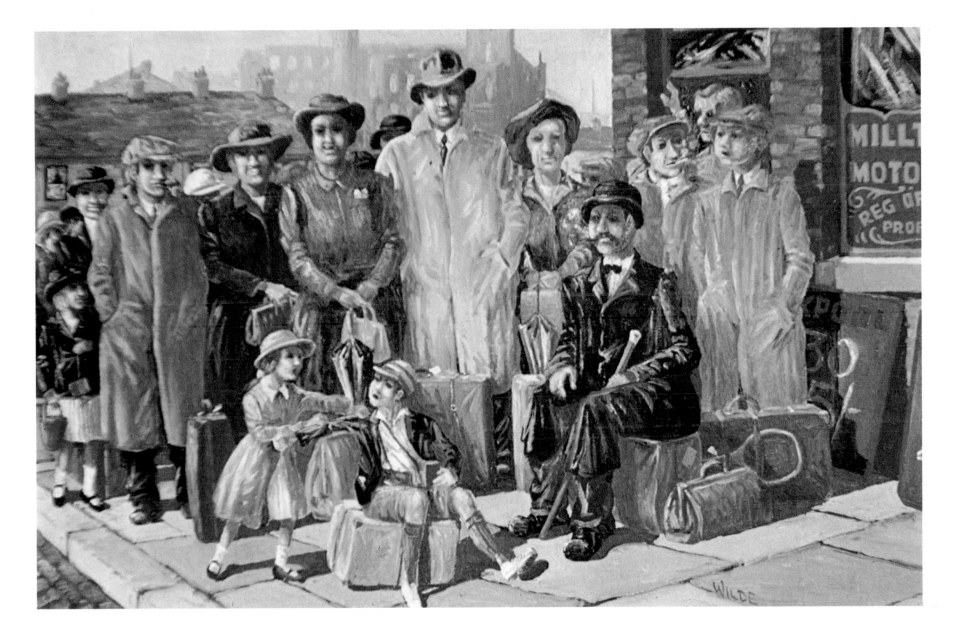

Be Prepared for a Trek-Cart Holiday

You joined a Scout group with a uniform and you learned about tracking and wood-craft and lighting fires with only one match.

You went in for proficiency badges: art, woodwork, cooking, etc.

You did a good deed every day, and of course you had a big knife on your belt which had a can-opener, screwdriver, huge blade and a spike for taking stones out of horses' hooves. (Did you every try that?)

The highlight of the year was the annual camp, when you were allowed out of parental control, albeit under the discipline of the Scout-master.

This outdoor camp was a godsend to poor families for it was the only way many boys could have a holiday.

A 'trek-cart', often an old, cast-off builder's trolley, was an essential. All the gear was loaded on: tents, groundsheets, Dixies, shovel; and all the troop pushed and pulled it to the camp site. No public transport was involved, so you had to be prepared for a long trek. But you got some admiring glances on the way.

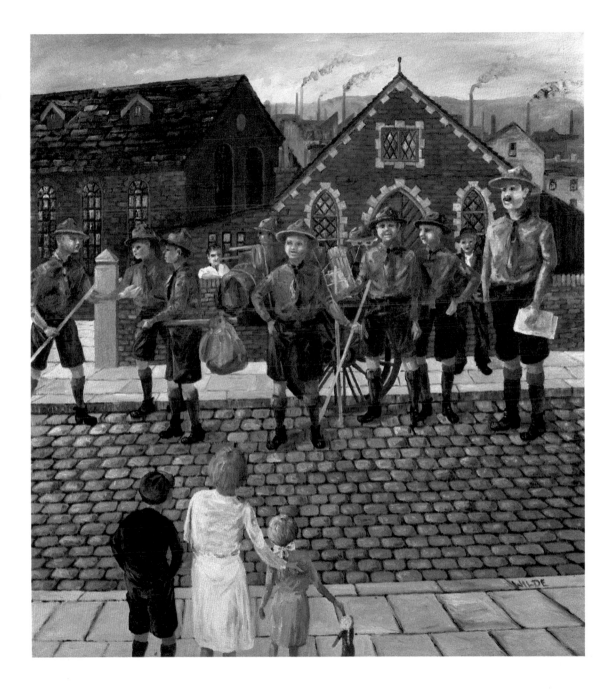

Down to the Sea

The tide is on the way out, leaving behind it a clean, smooth page of empty beach for castle building, bucket-pie making, for channelling and dam-making.

And the whole beach belongs to you, for a whole week – well, as much to you as it does to anyone else.

On the way down there are all the sea-side shops adding to the magic of 'Wakes-week'. There are cafés (with Hovis teas), present shops, rock shops, and general stores selling toys for the beach, model yachts, fishing winders, buckets and spades and Bamforth's saucy postcards.

It's good to be going down to the sea, far better than coming back again.

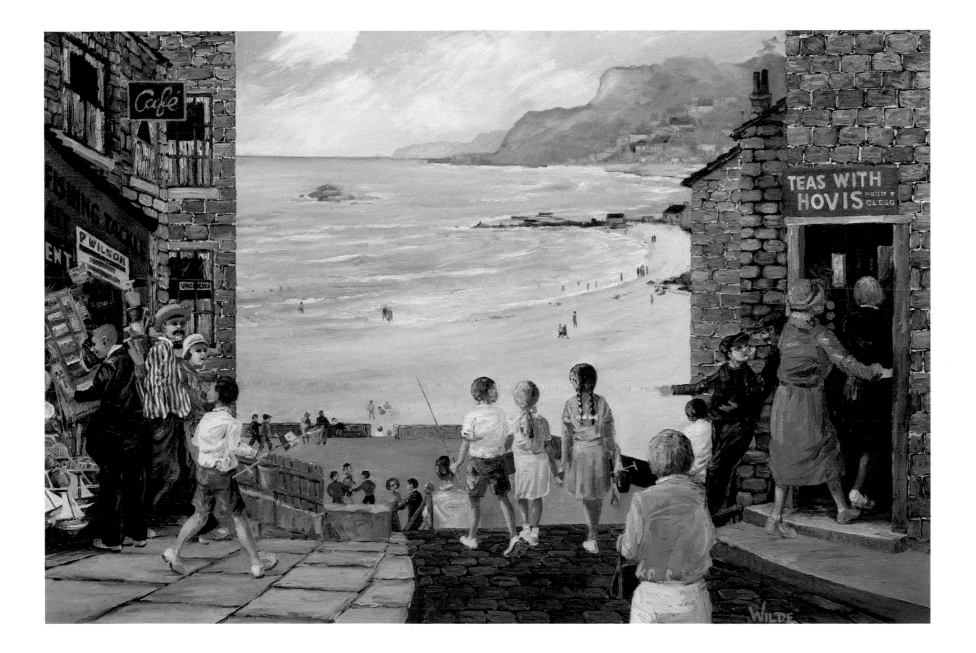

Riding on a Donkey

'No, I don't want a bunk up, thank you. I can manage.'

This was one of my chief delights. They moved at a discreet amble, in a bunch, and your bare legs were rubbed by the jostle of fur and stirrups. No matter how hard you tried, your mount could never be stirred into a cowboy gallop.

When the convoy reached the end of its allotted course the donkeys turned back of their own accord for the return stroll. No matter how you urged them on and dug your heels into their flanks they couldn't be induced to go a foot beyond the approved distance.

It was a very simple, naïve pleasure, but how I looked forward to it – and now look back to it!

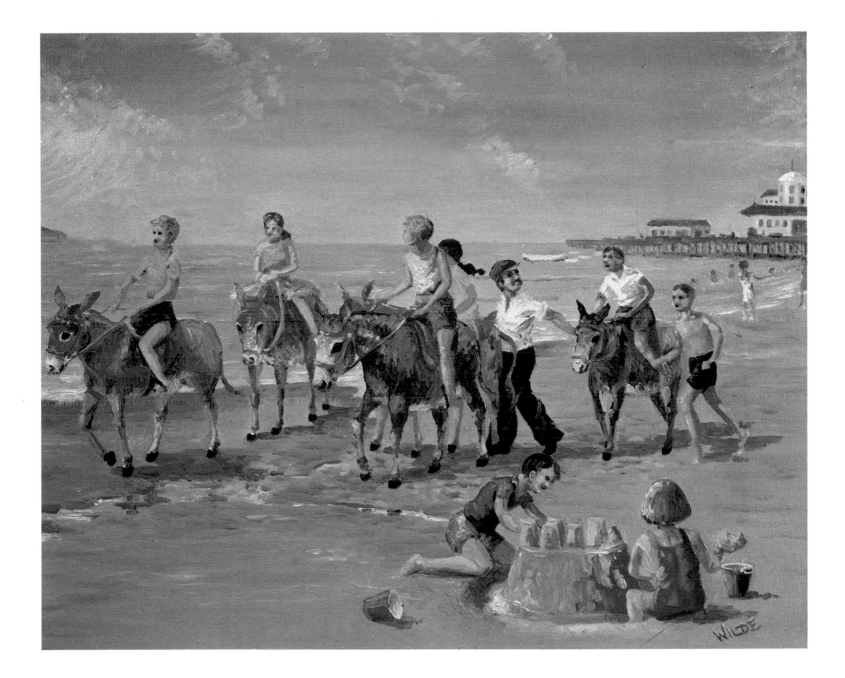

Punch and Judy

We are told now that their origins were in the dim and misty past. Punchinello, Columbine, Harlequin and all that lot are amongst the oldest performers in the entertainment business.

What it is about the story of Punch that continues to appeal to a young audience? Is it the fact that the characters are so obviously dolls or make-believe puppets? Or is it that unmistakeable croaking voice in which they speak?

One thing is quite certain, though. The chief character is a reprobate of the first order – a con-man, a delinquent, a wife-beater, even a murderer. His whole career is a history of violence, crime and mayhem.

And yet, as he storms through his dastardly life he is not greeted with a shudder of fear or shrieks of terror. On the contrary! The child audience hoots with laughter and 'rolls about' with delight at this ancient and shocking riot.

I wonder why? Yet, as Punch himself proudly announces, 'That's the way to do it!'

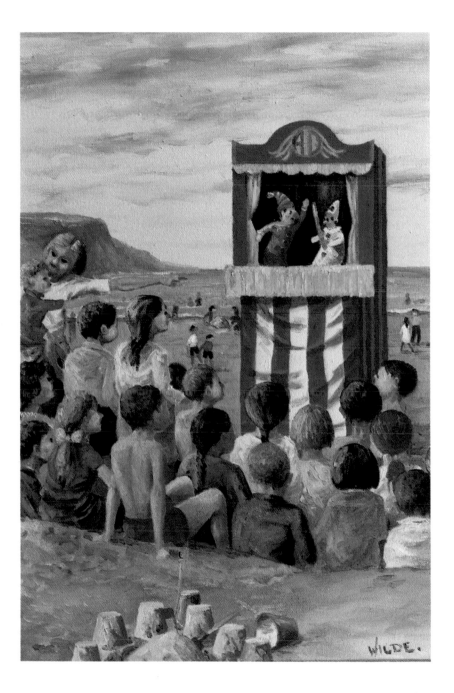

'Where's the Best Place to Fish, Please?'

'Well now, it depends what yer after, don't it?

If it's Shark or Dog-fish yer after yo'd best goo down Cornwall, round about Eddystone light, ah reckon.

Then agen, if it's Salmon yo' want, Scotland 'd be t' best.

But ah reckon yo' dunna want owt fancy same as that, s' yo'd bi t' best off on t' th' owd jetty, ger on t' far side an' fish wi' t' tide.

W'at've yo' getten fer bait, Mussels an' Lugg? Well, yo' conna do better ner Lugg. Fish about four foot wi' a little float an' yo'll likely geet some grey Mullet. But, by gow, tha'll a' to bi sharp: they're canny biters 'r Mullet.'

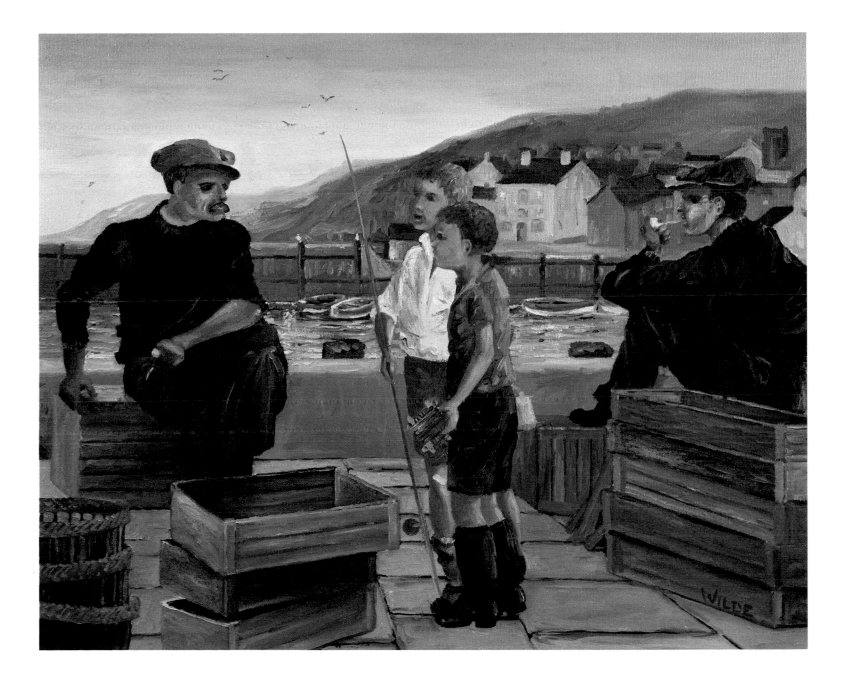

Digging for Lugg

Look for the tell-tale, sand-sculpted worm-casts on the still wet shore; that's where they lurk.

But it's useless to dig just any old where; you'll soon exhaust yourself doing that.

What you have to do is pad carefully round the tell-tale worm-cast, and at some point you will see a small funnel-shaped depression which will well-up with water as you tread.

That's where he is! So dig from the funnel towards the cast and if you have got your direction accurate and you dig deep enough and fast enough you'll have him.

Good luck, and tight lines!

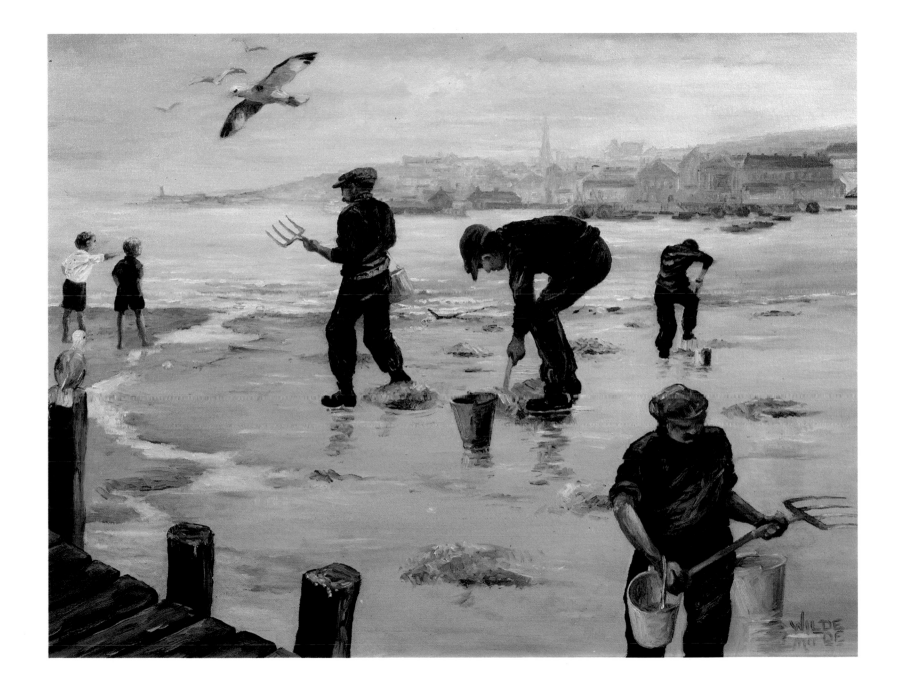

'Where did That One go To?'

Those grey-ghost shrimps and little blennies left behind in the green, weed-festooned rock pools were our elusive quarry.

As fugitive as shadows, quicker than the eye, they darted ahead of our hopeful nets and often all we saw of their lightning escapes were tiny dust-clouds of settling sand in the place from which they had fled.

'Where did that one go to? Are'nt they quick!'

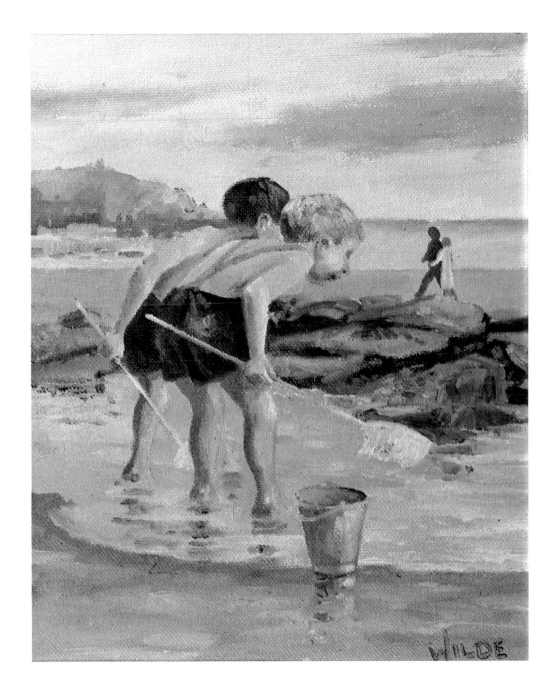

Fishing from the Pier

Many were the attractions of the pier ... Penny-in-the-slot machines with footballers dressed in knitted jerseys, always with loose, trailing ends of wool. Then there was 'Fireman, Save my Child' and 'The Public Execution', 'Fortune Tickets', 'Dad's Bit of Fluff', 'What the Butler Saw', and horsey little men wanting to guess your weight.

Then there were tea rooms, usually a band, and either a concert party or a pierrot troupe.

All these sophisticated pleasures were left behind by the time you came to the place where fishing was allowed.

For us, the dedicated few, there was nothing but bare boards and pipe-like railings and the odd life-belt.

Here you could bait your hooks with mussels, or, if you were lucky, with lugg worms, or as a last resort a piece of old cod's head. Then you would heave your line, complete with 'booms' and 'sinker', into the far-below, restless, grey sea.

Occasionally some lucky person caught a minute 'flattie', and there was great excitement. Clinging-for-dear-life crabs were thrown back, but the exceptional capture of a six-inch whiting was hailed as a tremendous achievement.

'Eigh, watch out! You're going to tangle mine.'

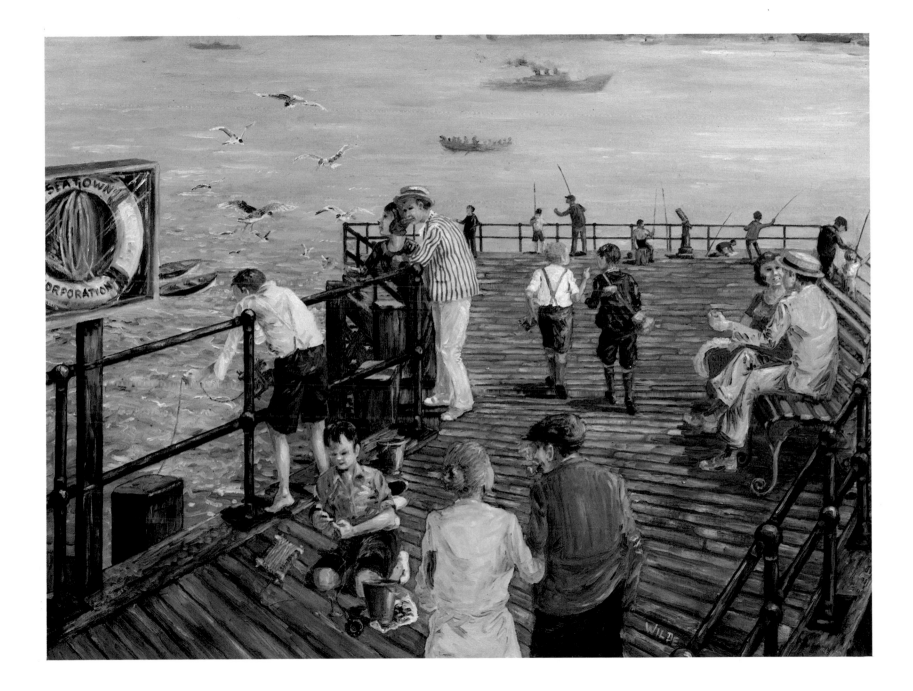

The Sea in Calm Summering

One of the lovely stories of my childhood was about the Kingfisher, the flamboyant Halcyon.

The Halcyon was a magic bird, remarkable for its beauty. It nested on the sea, and the waves lay down, in flat calm, until the eggs were hatched . . . the Halcyon days.

The years bring reality and disillusion, I now know the Kingfisher is not a sea bird, but can I not think of Halcyon again when the sea rests in calm summering?

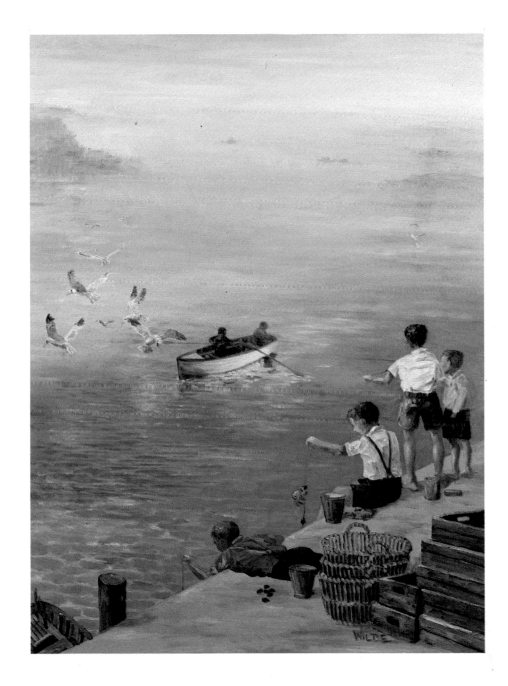

'Back in Time for Tea'

On the big lake in the sea-side park was a steamer with a boiler, a tall red funnel which trailed behind it a ribbon of smoke, and a red and white striped awning – all very gay.

For adults sixpence, children threepence, you could sit on its vibrating seats and be chuffed round the grey water, past the tropical palm-house and the grotto.

We prided ourselves on quickly picking up the nautical terms, for we are a sea-faring nation, though port and starboard were difficult to be sure about, at times.

Everyone wanted to sit in the stern, for there you could trail your fingers in the turbulence of the screw for an added enjoyment.

The 'Captain' sported a naval peaked cap with a white top and he stood by the gangway encouraging us with 'Any more for the Skylark?' and 'Back in time for tea'.

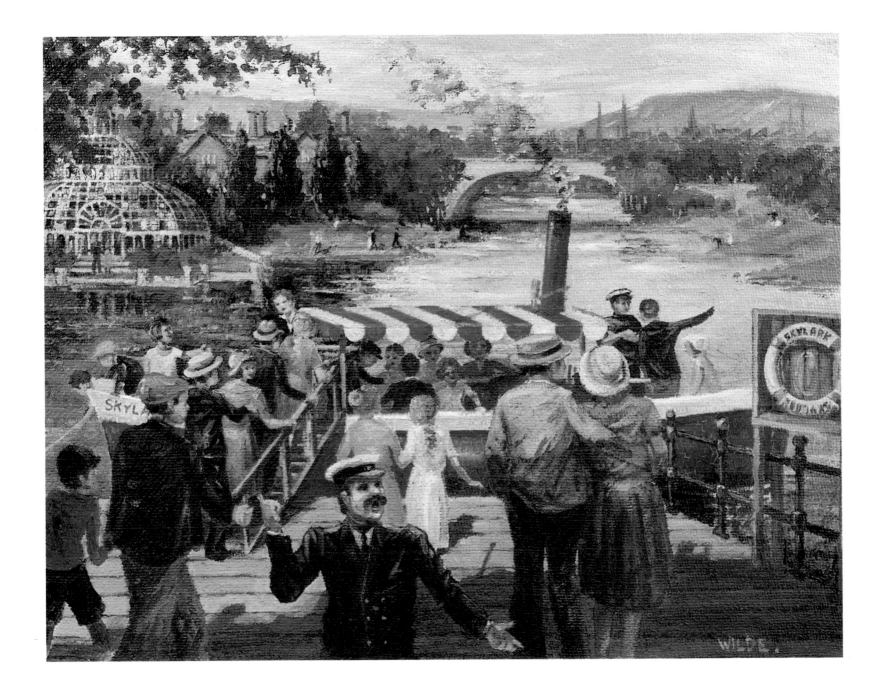

Spinning for Mackerel

The blue or green mottled mackerel is built for speed, like its larger relative, the tunny. You can tell that by the cut of them. Fierce predators they are, going in vast shoals to feed upon the masses of baby fish known as whitebait.

Often you can tell where the mackerel are by the hundreds of screaming sea-birds which congregate, hysterical with opportunity, feeding on the superabundence of tiny fishes.

It is a good bet that the mackerel will be taking their toll underneath.

You need spinners to trail behind your boat, to simulate small fish. Two, three, or even four may be used towards the end of the line, on booms, which are often made from old tooth-brush handles fastened at right angles to the line to trail the spinners clear. A weight is, of course, necessary to hold the spinners down in the water. This gear is trailed behind the boat through the mackerel shoal, and sometimes the catch is momentous, for the mackerel is a bold fish and one of the cleanest feeders in the sea.

The Bandstand

It was the same band which, in the evening, dressed itself in 'penguin suits' and became the Palm-court Orchestra.

Then they played Strauss and musical comedy items to dance to whilst holiday-makers waltzed ('Do you reverse?'), or fox-trotted or Charlestoned in abandon between boarding-house dinner and fish-and-chip supper.

In the park they played much more robust tunes: marches by Sousa, selections from *William Tell* and *Carmen*, and always the *1812 Overture* – the red-faced drummer loved the cannon burst at the end.

Our parents sat on twopenny chairs, but we, soon bored, went to play 'topple-tails' down the 'keep off' grass and got chased by the 'parkie'.

'Aw, come on, let's get back to the sands.'

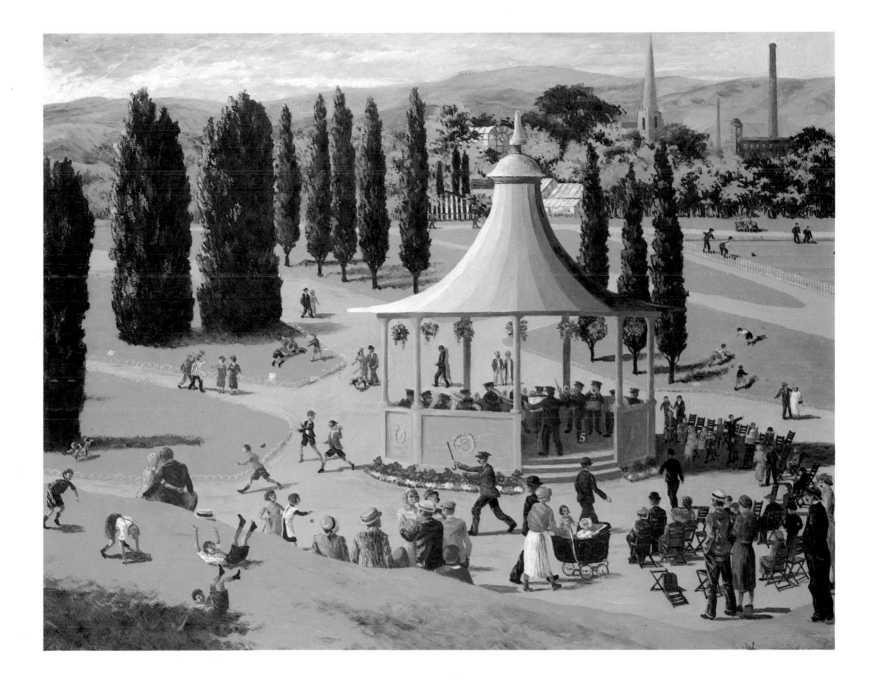

The New Box Brownie

That wonderful invention which made snapshooters of us all!

That marvellous carton with the blinking shutter-eye which captured the present, which is now our past, and holds it for the future.

It brought photography within the reach of all, capturing groups, portraits and moods on a roll of celluloid.

I still have one, bought in 1927 for the sum of 12/6d (old money), and if called upon it would still take good photographs!

Smile, please!

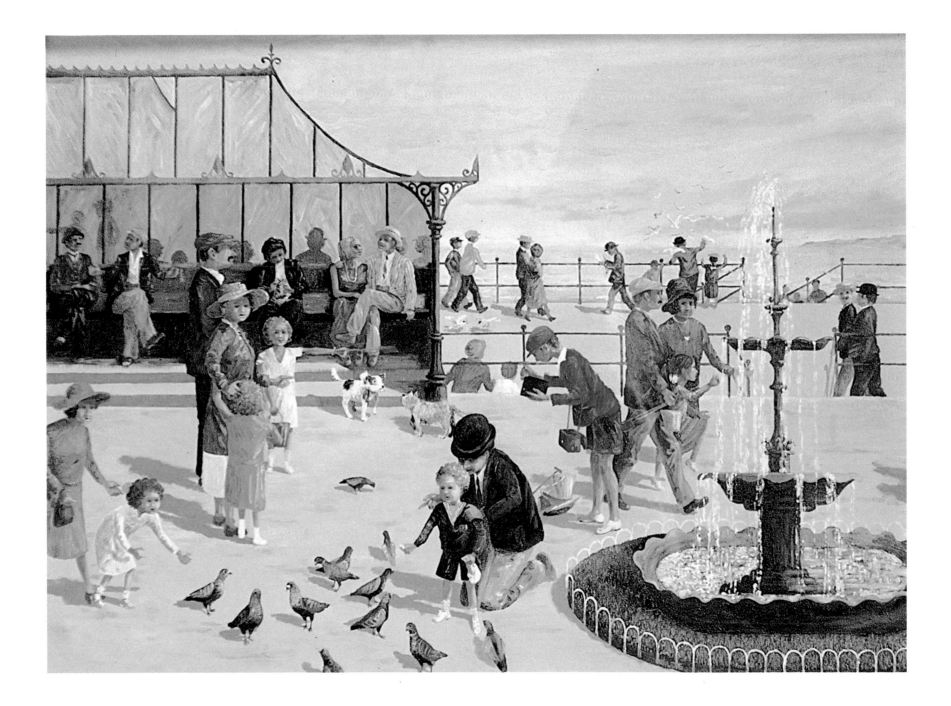

'Pots of Tea for Sands'

A great institution was this 'Pots of tea for sands'.

Freshly made ambrosia it was, which transformed the home-made pasties and sausage rolls and picnic sandwiches into a feast.

'What we want is a tray with three cups and saucers, a jug of milk, another of hot water for filling up, sugar, and a big brown pot full of strong tea.'

'Let's see, that'll be three shillings for the tea and a pound deposit on the tray and pots.'

'Don't you think it's time you went for it, Dad?'

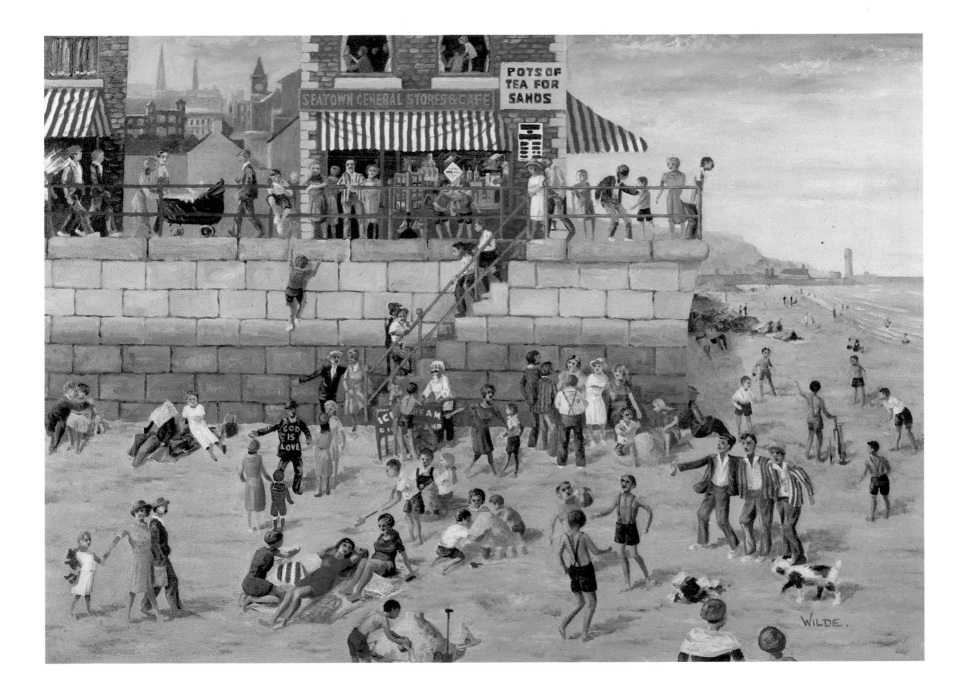

Sea View

The little summer cottages were so quaint and picturesque in the August sunshine that you longed to change your home town streets for the broken pathway, the awry steps, and the unending holiday shore.

But, as Dad says, 'Why do you think the path and the steps are broken and damaged? Think of the winter gales and the high tides of November, when the sea comes up here to look at the view and batters itself against the front door. How would you like that, eh?'

It's lovely now, though.

'Aw, Go on, Dad, Just this Once'

During the first world war the heavier-than-air machine began to display its staggering potential. The Royal Flying Corps was formed and did cavalier service. But when the war was over and the young 'heroes' were demobbed there was massive unemployment.

What more natural then that some of them should seek a livelihood in the flying that they loved?

Small aircraft appeared on many of our flat, sandy beaches, offering mild adventure to holiday-makers in the shape of ten-minute 'flips' round the town. These flights were only for the adventurous or foolhardy.

'Flips' were expensive, and we were always told we had better things to do with our money. Or was it just a case of parental stuffiness? 'If God had intended us to fly . . .'

It was thirty odd years before I did go up.

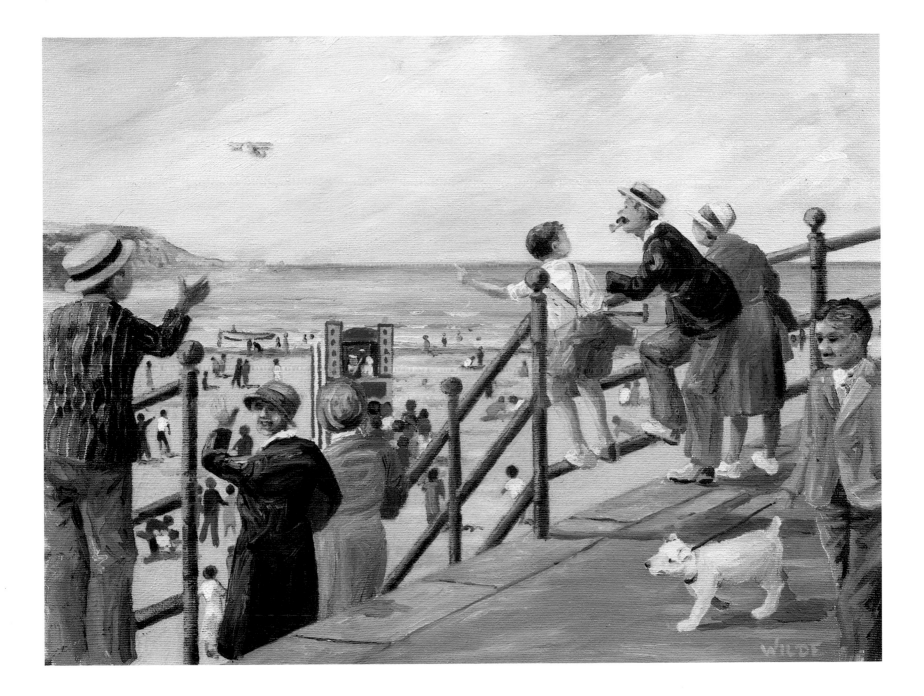

Feeding the Seagulls

The ever-hungry raucous gulls gyrate like a whirlwind of torn paper fragments. With their great gapes of wicked-looking yellow beaks they utter lost-soul screams.

Throw bread into the air and several will try to take it. They come so close to each other, in their seeming hysteria, that collisions appear inevitable; but never do they touch one another, so precise is their flying.

One or other will take the thrown morsel, and if it is of swallowable size it is dispatched at once. If too large to be swallowed it is often dropped, and is pounced upon by others in its fall. And all the while the stalling, side-slipping, hovering goes on, and screams assail the sky.

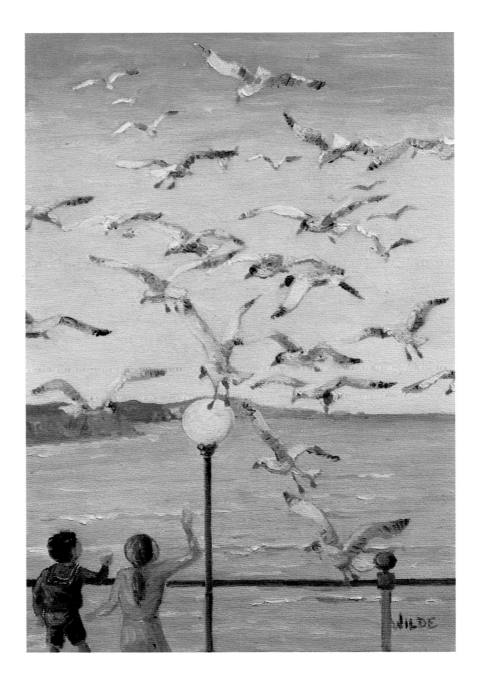

The End of the Pier

In the little pavilion at the end of the pier were the Pierrots, in their 'dunce' hats with black bobbles, and similar bobbles down their white coats, for buttons.

There was a very pretty young lady who sang soppy love-songs with her boy-friend, and a deep-down-in-the-boots bass singer who rendered 'My old Shako', 'Sailor, beware' and 'Drinking'.

They performed funny sketches, some of which made the grown-ups laugh, but didn't seem funny to me.

Best of all was the chief comedian. My Dad said he was a 'card'. He had a laughing face, a red nose and a loud voice. His jokes were as old as the hills . . .

'My wife's gone to the West Indies.'

'Jamaica?'

'No she went of her own accord.'

and:

'Waiter, there's a fly in my soup.'

'Not so loud, sir, or they'll all want one.'

It was the pianist who worked hardest. He had to play for everyone, whether singing or dancing, and in between as well.

I used to wonder whether they named the Pierrots after the pier, or *vice versa*.

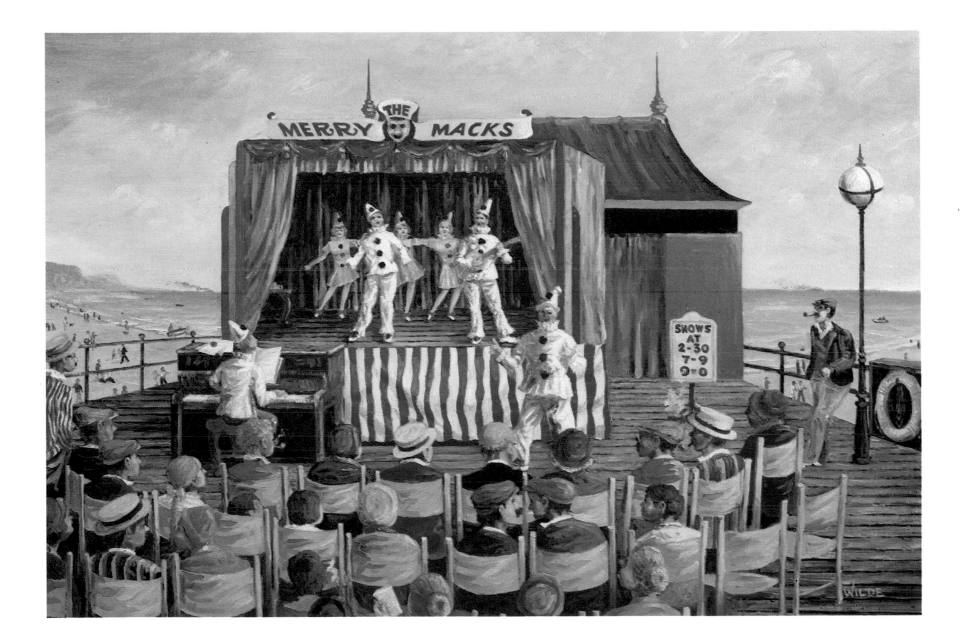

The Seventh Wave

When I was a good deal smaller than I am now, a lot nicer and even more naive, I was told that the sea came up rampaging in sevenths . . . six small waves and then a king-size.

I believed this implicitly, having no reason to doubt my mentors; it is likely that they believed it too.

Often I tried to count the waves as they came rolling in, white-lipped and veined, with froth in their teeth as they crashed upon the shore.

Sometimes I could persuade myself that the seven myth was true, but I could never tie it down for sure.

But doubts multiply with age and I'm still not quite sure, thank goodness! How about you?

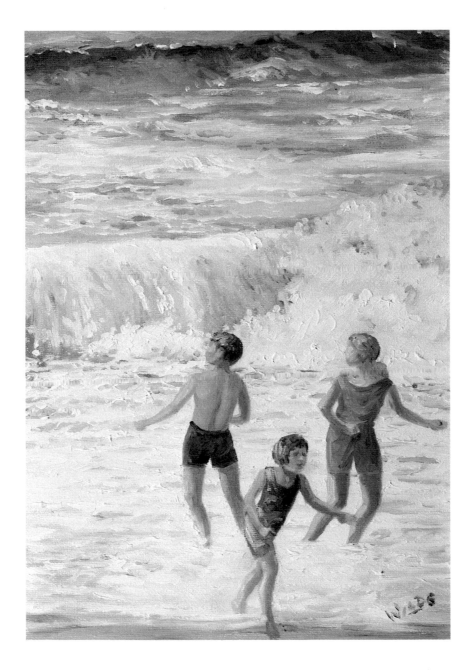

'Come on in! It's Grand!'

Everyone knows that it *isn't* grand really . . . healthy, perhaps, but not *grand*.

Everyone is aware that our grey northern seas are anything but grand, they are cold and unwelcoming.

But ever since that walrus-mustachioed, mutton-chop-side-whiskered Victorian medical man pronounced his saline commendation we have been forced to become sporadic dippers and swallowers.

From the days of the voluminous-suited, bloomer-clad Victorians trundling to the sea's edge in hooded bathing machines, until today we have been urging each other on with the encouraging half-truth 'Come on in! It's grand!'

And everyone knows it isn't really, not up here, anyway.

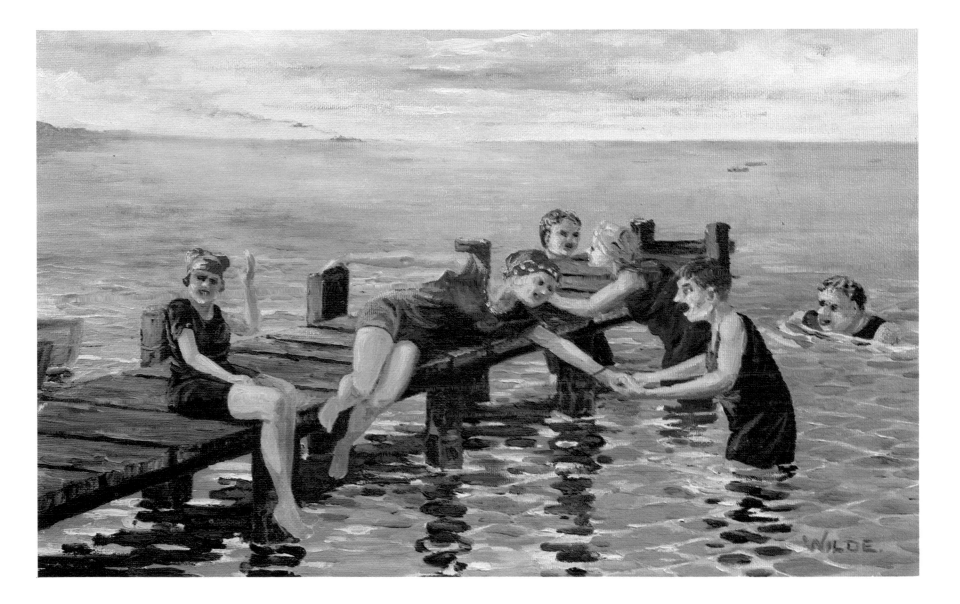

Canute II

The original King Canute was flattered into trying it by his sycophantic courtiers, so we are told, but he was no more successful at tide-stemming than have been numerous imitators since.

If seven maids with seven mops couldn't do it, what chance did one small boy stand with just one little bucket?

Still, it was fun trying, and it was an excuse for getting wet.

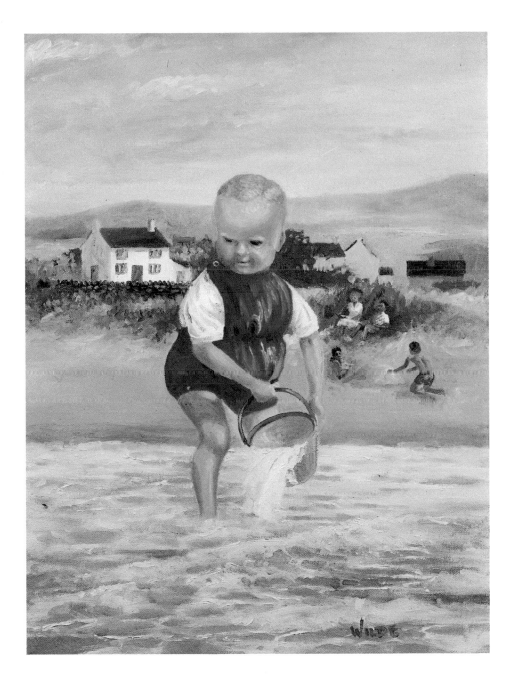

'It's Good fer t'Bunions'

Was it really good for bunions? I don't know, for I never suffered from them; but it was an old and generally held belief.

The annual soaking of the trotters could not have done any harm, and it was certainly a pleasant change for the year-long-boot-bound feet. And sand between the toes can be a joy.

But northern seas are usually so cold that they come near to anaesthetizing the extremities – so much so that you wouldn't notice the ache of the bunions if you had any.

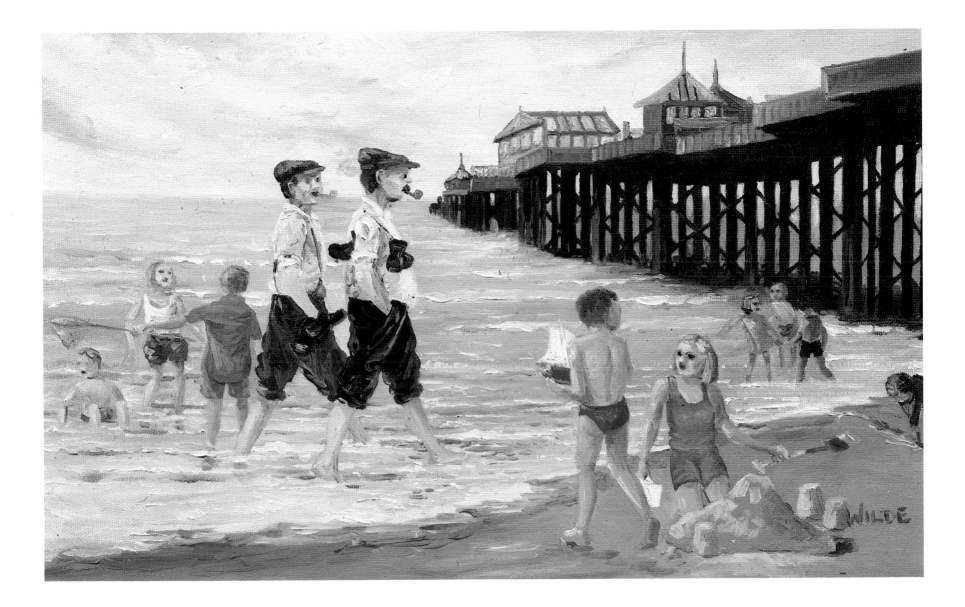

Lobby Lud

Between the wars one of the national daily newspapers hit upon a great sales gimmick. Every day throughout the holiday season they published a difficult-to-identify photograph of a particular member of their staff. The picture was taken from some disadvantage point, perhaps from behind his ear, or with his hat over his eyes. This gentleman suffered or gloried in the pseudonym of Lobby Lud.

Along with his photograph the paper would announce that the said gentleman would visit a specific sea-side resort the following day.

If any reader had the luck to recognise him and was bold enough to challenge him correctly, viz 'You are Lobby Lud, I am a regular reader of the . . . and I claim the £5 prize'.

Then the fortunate reader, if he were in possession of a current copy of the newspaper, would receive his prize.

There is no doubt that this gimmick sold a lot of newspapers, and it is equally certain that many innocent, holiday-makers were accosted. If rumour is to be believed some of the importunings resulted in bouts of fisticuffs.

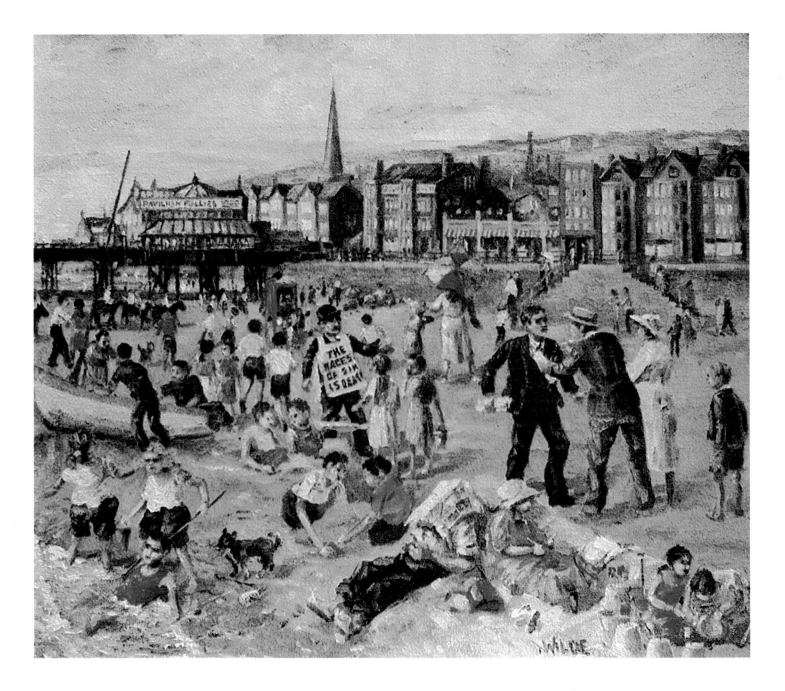

A Good Day for Ludo

'Rain, rain, go away,
Come again another day.'
Nasty it is, can't go on the sands, can't go on the quay, can't even go for a walk.'
'Sick of cutting out, can't think what to draw. I've read all the comics.'
'I KNOW.'
'Let's play Ludo, I'll have red.'
'Well, bags I first go, then. I'll shake a six first time, you see.'

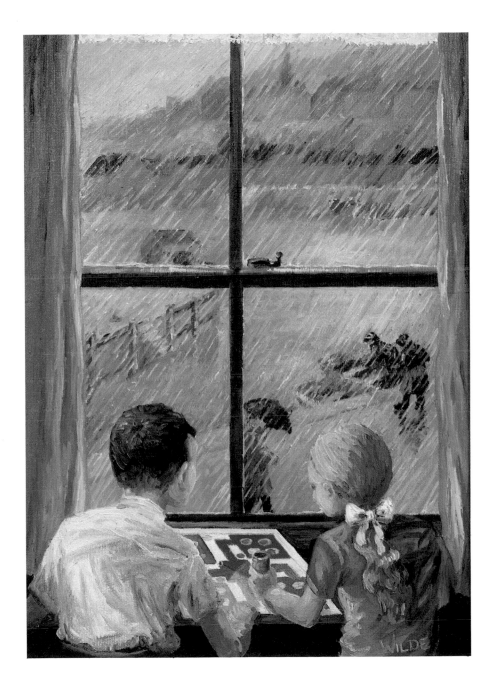

Quiet Holiday

Away from the 'Kiss-me-quick' hats, the Lawrence Wright song pluggers . . . ('Peggy O'Neill' and 'Glide my golden dream-boat'), away from the mock auctions, the noise, the bustle, the crowds.

No Winter Gardens, Circus, Pierrot, Punch and Judy; but in our pools are star fish and grey-ghost shrimps and pink anemones.

The sand is good and there's room to play cricket.

Our landlady's husband has a boat with Crab-pots and he's going to take us out one day; he also has a hutch in the back garden with ferrets in it.

You can't take a Lobster under seven inches, and watery crabs are no good.

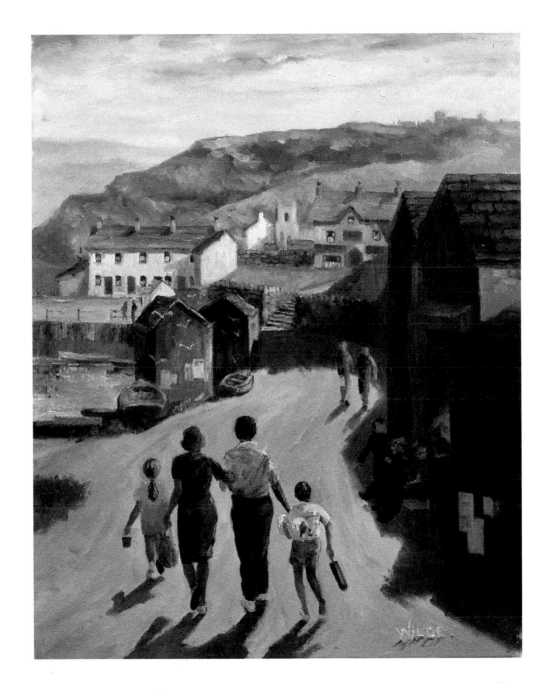

'A Funny Thing Happened . . .'

A visit to the Winter Gardens was one of the wakes-week treats. Oh! what magic was there in the theatre, the excitement of something wonderful just about to happen. People bustling about seeking their seats. People who have already found theirs, standing toe-tucked, to let you pass. 'Excuse me,' 'Thank you,' 'Sorry.'

Then settling down in your upholstered 'fauteuil', overcoat off, sweets handy, 'How long yet, dad?' At last the lights go dim and you hug yourself in anticipation; the curtain parts and the wonder begins. The world beyond the footlights is a magic one, full of larger-than-life people, beautiful, marvellously talented: dancers, singers, instrumentalists, glorious comics. Soon we were totally caught up in the spells they cast.

Those were the last of the great Music-hall days, and I was lucky enough to see a few of the giants – Little Tich, Nellie Wallace, George Robey, Randolph Sutton, Gracie Fields and George Formby. Once, as a boy of thirteen or so, I saw Dorothy Ward. She was beautiful beyond anything I had ever seen.

I now know that she must have been much older than my Mother, but what difference would it have made had I known then?

All I remember is that I fell 'hook, line and sinker'. I was completely captivated by a golden vision, and it is still a wonderful, treasured memory.

Years later I came upon someone else . . . but that is another story.

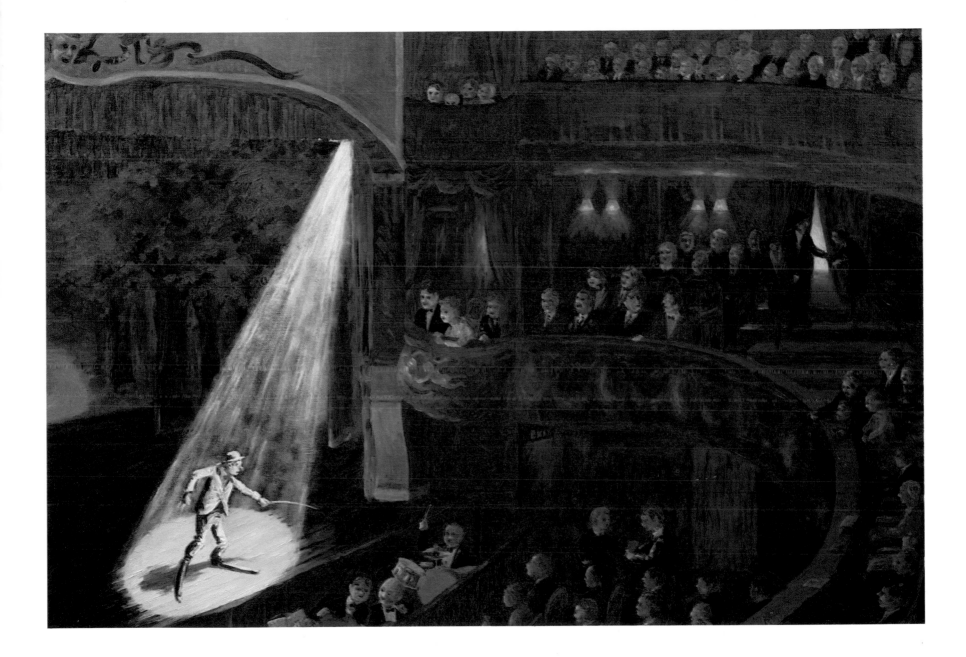

The Pier at Night

The pier is a spider tracery jutting out into the sea with snake-wriggles of reflected lights sparkling in the dark and restless water.

Crowds of wakes-weeking holiday makers wander slowly along its board-walk promenade, as the sea slaps and gurgles far below against the musselled piles.

For almost three quarters of a mile it reaches its entertainment-studded arm out to sea. The fresh ozone of the moving air is a tonic for lungs which, for the other fifty-one weeks, have been taking in their regular quota of cotton lint.

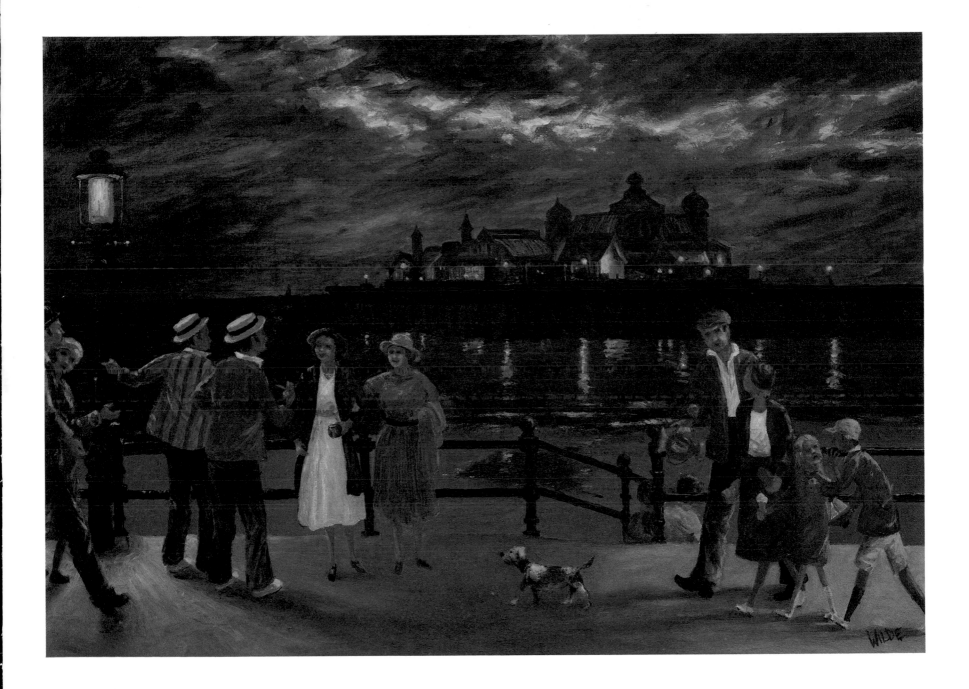

The artist is grateful to those listed below for permission to reproduce paintings in their possession:

Mr and Mrs K. Smith	Down to the Sea
Mr and Mrs K. Mordaunt	'Where's the Best Place to Fish, Please?'
Mr and Mrs K. Mordaunt	'Digging for Lugg'
Mr and Mrs D. Franks	Fishing from the Pier
Mr Edward Woodward and Miss Michele Dotrice	The Sea in Calm Summering
Mr D. Robinson	Pots of Tea for Sands
Mr and Mrs L. Jackson	'Aw, Go on, Dad, Just this Once'
Miss J. Cardwell	The End of the Pier
Mr and Mrs G. Bell	'Back in Time for Tea'
Miss G. M. Benton	It's Good fer t'Bunions
Mr and Mrs K. Mordaunt	Spinning for Mackerel
Mr and Mrs G. Milton	The Bandstand
Miss Lindsey Reynard	The New Box Brownie
Mr and Mrs L. Jackson	Punch and Judy
Miss Emily Beth Woodward	The Seventh Wave
Mrs M. Simpson	Lobby Lud
Miss Teresa Preland	'A Funny Thing Happened . . .'
Mrs E. Court	The Pier at Night

The painting on the title-page is a self-portrait by the artist.